Wisdom With
Understanding
is Better
Than Rubies

Lurine Karon Greenberg
Fine Arts Collection

half life

Anna Gaskell

half life

MATTHEW DRUTT

THE MENIL COLLECTION

This catalogue accompanies the exhibition *Anna Gaskell: half life* presented at The Menil Collection, Houston, September 27, 2002– January 12, 2003.

Unless otherwise noted, all works are courtesy Casey Kaplan Gallery, New York.

Designed by Miko McGinty
Edited by Diana Murphy
and Lucy-Flint Gohlke
Printed by Artegraphica S.p.A., Verona, Italy

Published by Menil Foundation, Inc.
© 2002 by Menil Foundation, Inc.
1511 Branard, Houston, Texas 77006

ISBN 0–939594–54–4

PRINTED AND BOUND IN ITALY

CONTENTS

Preface

THE MENIL COLLECTION is once again pleased to present a new body of work by a young artist created especially for exhibition in its spaces. Opportunities such as these exemplify the spirit of adventure and dialogue that John and Dominique de Menil embodied as collectors, and we are therefore honored to have worked directly with Anna Gaskell, an artist of international distinction, to realize this marvelous project. We are most grateful to her for her unique talent and dedication, and to Matthew Drutt, Chief Curator of The Menil Collection, for his capable and inspired organization of the exhibition and publication.

LOUISA STUDE SAROFIM
President, The Menil Foundation, Inc.

Acknowledgments

ANNA GASKELL'S *half life* began as an idea for a film installation and quickly evolved into a more ambitious exhibition of still and moving images that envelops audiences in another of the artist's trademark fictional realms. Drawing inspiration from stories like Daphne du Maurier's *Rebecca*, Elizabeth Gaskell's "The Old Nurse's Story," and Henry James's *The Turn of the Screw*, Gaskell offers us a dreamlike sequence of works that plumb the dark recesses of the human psyche, embodying a sense of fear, isolation, and uncertainty. Commissioned by The Menil Collection, *half life* not only exemplifies Gaskell's aesthetic versatility and polish, but also represents a phase of growth and experimentation in her work. It is the first time that she has conceived still and moving pictures in concert with one another, and whether by design or happenstance, the syntax of her images has become more abstract in the process, creating a mood suggestive of presence by virtue of absence.

We are indebted to Karolina Zelinka, Administrative Curatorial Assistant, who expertly managed all aspects of the project at the Menil, with further support provided by Susan Braeuer, Project Curatorial Assistant. We would also like to thank Chana Budgazad and Haan Chau, and their interns Jacquelyn Johnston and Carey Hartman, at Casey Kaplan Gallery in New York, who were helpful throughout the realization of the exhibition and publication. In this regard, we must express our profound gratitude to Casey Kaplan, whose support was essential to the project's success.

We are very pleased once again to have had the opportunity to work with Miko McGinty on the design of a publication. She is to be thanked not only for her creative energy and guidance, but also for her rapid mastery of the project. Richard Massey is acknowledged for his creative suggestions in the early phases of this undertaking. We also wish to thank Niall MacKenzie and Francis McKee for their contributions to this book. Their words significantly augment the ideas embodied in Gaskell's work. Thanks are also due to Diana Murphy and Lucy Flint-Gohlke for their careful editing of the texts.

Our sincere appreciation is offered to Deborah Velders, Head of Exhibitions and Programs at the Menil, and Anne Adams, Registrar, for their effective management of the exhibition. We extend thanks also to the Menil's Exhibitions staff—Mark Flood, Anthony Martinez, and Brook Stroud— and to Art Services staff members Doug Laguarta, Gary "Bear" Parham, and Tom Walsh for their skillful installation of the show. We are grateful to Phil Davis for his assistance with the presentation of the film. We thank cinematographer Michael McDonough, film editor David Archibald, and the postproduction team at the Farm Group in London. We are further indebted to ASL, Leigh Anne, Ellen Goldberg, Leslie Kaplan, and Katie Nicoll for their assistance with the film's production, and to Susan Talbot and the Nancy Graves Foundation for their generous support of it. Additionally, we would like to express our thanks to Ben and everyone at Hong Color in New York for their work on the photographs, as well as to Andreas Kornfield and Julie Piechowski for their help in production. Special mention must be made of the Times Square Church, National Arts Club, and St. Regis Hotel in New York for providing locations.

Other colleagues at the Menil who supported this exhibition in invaluable ways include Elsian Cozens, Special Events Coordinator; Marta Galicki, Membership Coordinator; and Vance Muse, Director of Communications. We are grateful to Management Committee colleagues Will Taylor, Director of Planning and Advancement, and John Reed, Chief Financial Officer, for their encouragement and input, as well as to James T. Demetrion, Interim Director, for his enthusiasm for the project and sage advice. We are most indebted to the Trustees of Menil Foundation, Inc., for their continued stewardship of the institution and the guidance they provide to its staff.

A number of individuals outside the museum must be thanked for the support of this endeavor and Gaskell's work in general: Elizabeth Belin, the BG's, Gisela Capitain, Piggy Fleabag, Douglas Gordon, Jay Jopling, Jeanne and Mickey Klein, Yvon Lambert, Tony Podesta, Claudia Schmuckli, and Debra and Dennis Scholl.

Most of all, we thank Anna Gaskell. Her talent and ambition reached a new level with this project, which was completed amid a number of challenges, not the least of which was the birth of her first child, James Gray Gaskell Gordon. It was a privilege to collaborate on a project with her and to continue a dialogue that began in 1995. For this ongoing and productive relationship, and the generosity she and Casey Kaplan displayed in their gift of the film installation to The Menil Collection, we express our deepest gratitude.

MATTHEW DRUTT
Chief Curator, The Menil Collection

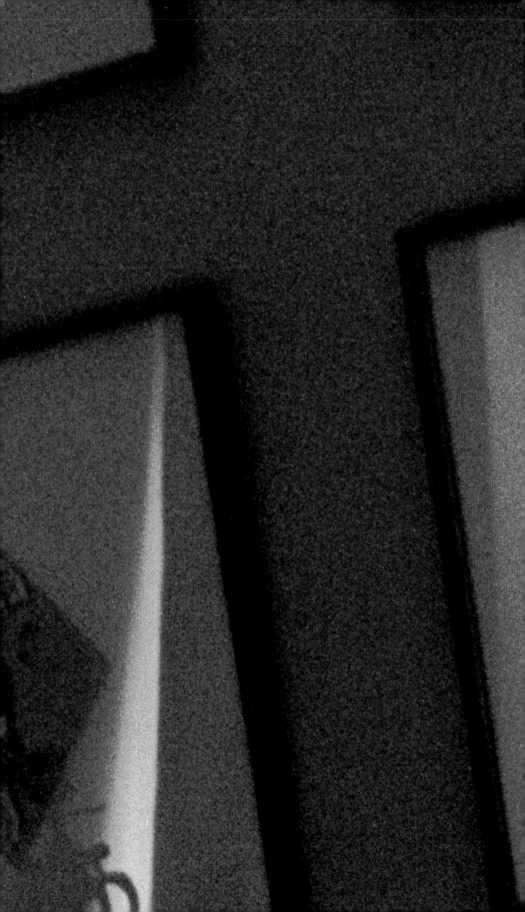

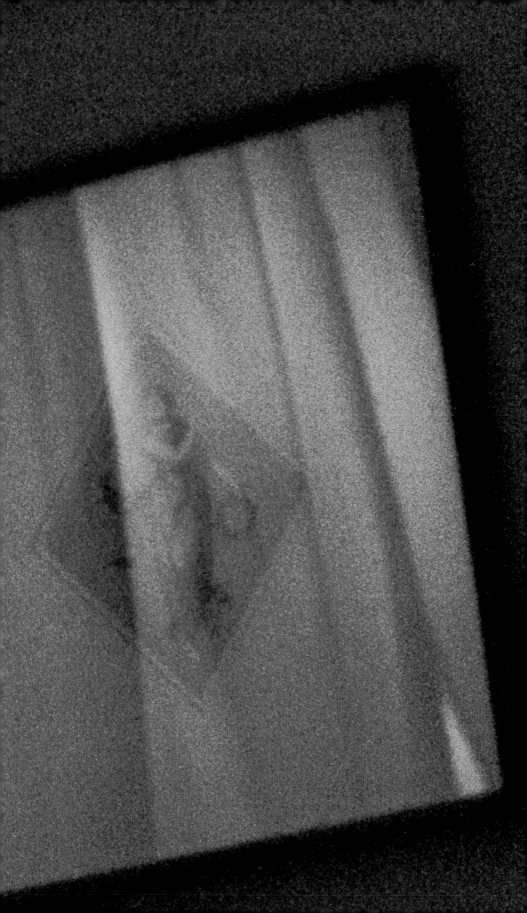

Anna Gaskell: half life

MATTHEW DRUTT

ANNA GASKELL is prominent among a generation of artists who emerged in the late 1990s to redefine the landscape of contemporary art. Building on appropriation strategies pioneered a decade earlier by artists such as Cindy Sherman and Laurie Simmons, Gaskell has championed a new discourse in which narrative is disrupted, stripped of closure and connectivity, its fragments functioning like film stills excised from their context but suggesting a missing whole.

Since her first solo exhibition in New York in 1997, Gaskell's works have been described as "photo-based," a phrase often deployed for talking about artists who use the medium of photography conceptually, either departing from its iconographic traditions or exceeding its conventional boundaries of scale and composition to rival film and painting. Gaskell does both. To say that Gaskell's art is more concerned with painting and film than with photography not only acknowledges the importance that these media have played in her creative development, but also declares that her art has moved into a territory where the language of photography no longer suffices. In more recent work, the liberties that she takes with form in her richly textured tableaux are more painterly than photographic, while her

use of dramatic viewpoints, foreshortened depths of field, and stark contrasts of light and shadow are reminiscent of film noir. It is the combination of impulses in her work that is notable. Gaskell's images seduce us with their beauty while repelling us with a sense of unease, ambiguity, and portent, as if John Singer Sargent and Alfred Hitchcock had joined forces.

Her point of departure is often a text or several texts, normally a children's fable or ghost story, but on occasion she takes elements from macabre real-life events. Yet her works do not illustrate stories so much as emulate them. Past projects have drawn on *Alice in Wonderland, The Magic Donkey,* and *Frankenstein* for inspiration, but the texts are only beginnings—Gaskell strips these references down to their essentials, and then carefully builds up vignettes to form a new narrative that is only vaguely familiar and tenuously connected with its source. Further confounding our sense of the particular, she subverts the convention of seriality in both storytelling and photography by creating bodies of work that appear to narrate, but that thwart one's ability to draw clear connections among the images. As if to emphasize the point, she assigns numerical sequences to her works (*Untitled # 89, Untitled # 90,* and so on), when there is, in fact, no particular order in which they are to be seen. The circuitous narrative that results is like a journey without beginning or end, a kind of traveling without arriving.

Anna Gaskell: half life debuts a new body of work composed of ten photographs and a film installation, inspired in part by Daphne du Maurier's novel *Rebecca* (1938; and Hitchcock's cinematic interpretation of it, 1940), the story of a woman haunted by the unseen presence of her husband's deceased first wife.[1] Other texts that provide a conceptual

point of departure for the project include Elizabeth Gaskell's[2] "The Old Nurse's Story" (1906) and Henry James's *The Turn of the Screw* (1898). The Menil Collection itself was also inspirational in Gaskell's formulation of the work. Her art has much in common with Surrealism, operating in the realms of fantasy, horror, the subconscious, and female identity and sexuality. Thus, the Surrealist holdings of the Menil, among them, the photographs of Hans Bellmer, which have periodically informed those of Gaskell, provide a historical framework within which *half life* might be considered.[3] Moreover, the story of *Rebecca* is one that Gaskell thought about using for years, but it was not until she came to Houston and found herself keenly aware of Dominique de Menil's lingering presence at the museum that a suitable occasion arose. In that sense, *half life* can be regarded as an homage to the Menil founder's legacy.

The main body of the installation of *half life* is a sequence of photographs scattered across the wall in an erratic, intuitive manner that evokes the disjunctive nature of passages in a dream. The viewer is drawn into the lush interiors of a stately domestic space, replete with ornate fixtures, works of art, plush carpets, and dark furniture, all of which seems very Gothic and Victorian. Suggestive of one place, the images were actually staged at a number of different locations in and around New York City. This strategy is typical of Gaskell, who articulates imaginary places by weaving together unrelated fragments of various locales in the same way that her narratives are selectively culled from different literary sources.

As in all of her works to date, the main protagonist in *half life* is a young woman caught between the purity of youth and the gradual loss of innocence that comes with matu-

y artists who share a fasci-
nt girls, Gaskell celebrates
led their "under-the-radar
ess."4 Indeed, her previous
struggling with another, or
ychologically, as in *Untitled*
, the viewer is left to decide
always identically clothed,
the multiple personalities

ide), 1998
60 in.

of a single person. In *half li*

chological terror, and the o

ther to the forefront thro

the figure. When she does

ness of her surroundings

remains disguised beneath

sometimes the only indica

tled # 90. We are confronte

silence and loneliness, qua

broad, spacious views of un

are drawn into settings whe

absence, where the figur

watched, and where

role of a voyeur lur

Untitled # 88 or *Un*

Architecture

moldings, and fr

any of Gaskell's

tagonist as settir

in the series. Ha

constraining h

detail. Staircas

leitmotifs, whi

extreme expre

be found in *U*

without even a

putti in the fr

invades the v

the same way that

90. The ultimate mome

series occurs when the sp

between viewing what the

one doing the viewing, a phenomenon already suggested in *Untitled # 91* and *Untitled # 96*, among others.

While Gaskell has employed both still and moving images in the past, in *half life* she conceived them specifically in relation to one another for the first time. It thus forms the most coherent presentation of these two poles of her work to date. Unlike the still images, which are oblique and ornate, the film is direct and minimal in composition. The photographs suggest a specific place, in which the viewer detects that something has just happened or is about to happen. The film is set nowhere in particular and suggests nothing more than what we see. A young girl is suspended underwater, eyes closed, not breathing, gray in complexion, apparently close to death. Silently, her body rocks back and forth with the motion of the current. One imagines that she is adrift. Occasionally her eyes open for a second, but they close again before we have had time to fully register it. Time stands still—for twenty-one minutes—and then the sequence begins again.

Drowning is a subject to which Gaskell has turned before. In *Untitled # 1 (wonder)* (1996), from her first major body of work, the figure of Alice from Lewis Carroll's celebrated story treads water in what viewers might construe as an interpretation of the passage where she is described as drowning in a pool of her own tears. An earlier film by Gaskell, *Floater* (1997), repeats a backward sequence of an Ophelia-like young woman in a pool of water, caught in relentless indecision as to whether to drown or save herself. This cycle of indecision is suggested again, more minimally, in *half life*. If read in relation to the fictional source, the image might be interpreted as showing Rebecca lying drowned at the bottom of the ocean. But Gaskell is never literal, and here one

cannot be certain that the girl is dead, dying, or even submerged in the water—an ambiguity suggested by the peculiar light contrasts between the water and her body and by the fact that her hair does not move or flow with the current. It is as frozen as the rest of the moment. In contrast to the young woman in the still images, whose identity is always concealed, the character in the film could not be more evident. Yet who she is remains just as unclear.

But it hardly matters. Just as trying to draw connections between the still images to arrive at a coherent narrative is an exercise in futility, so, too, is the attempt to reconcile the film with the stills. The film is a portrait. The photographs are faceless. Both are cogent expressions of Gaskell's manipulation of our need to reconcile meaning, and both

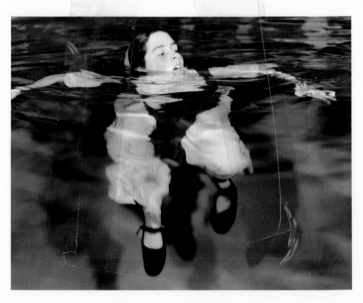

Untitled # 1 (wonder), 1996
C-print, 16 x 20 in.

18

successfully undermine our ability to do so. In making the viewer's experience synonymous with that of a photographic subject, the character in a film, or a fictional protagonist, *half life* represents a turning point in Gaskell's art, one in which her formal and conceptual approach to picture making has entered more abstract territory. Here the possibilities of storytelling have expanded beyond the concise rhetoric of a single medium, becoming more layered and interdisciplinary in the process.

NOTES

1. The film and nine of the ten pictures in *half life* were shown at The Menil Collection.

2. Elizabeth Gaskell and Anna Gaskell are not related.

3. It is no coincidence that Gaskell's exhibition was nestled into the galleries adjacent to the Surrealist collections.

4. Joy Press, "Girl Crazy," *Vogue* (Sept. 2002), 488.

As energy dispersed from the dead or dying, it would be converted or trapped in the surrounding environment, and in a house like this, coiling in on itself with little egress, it was more than likely that many such vibrations had been etched in its walls. A musician claimed that the dead could be captured on magnetic tape—a machine in an empty, haunted space could pick up voices that were normally inaudible to human ears.

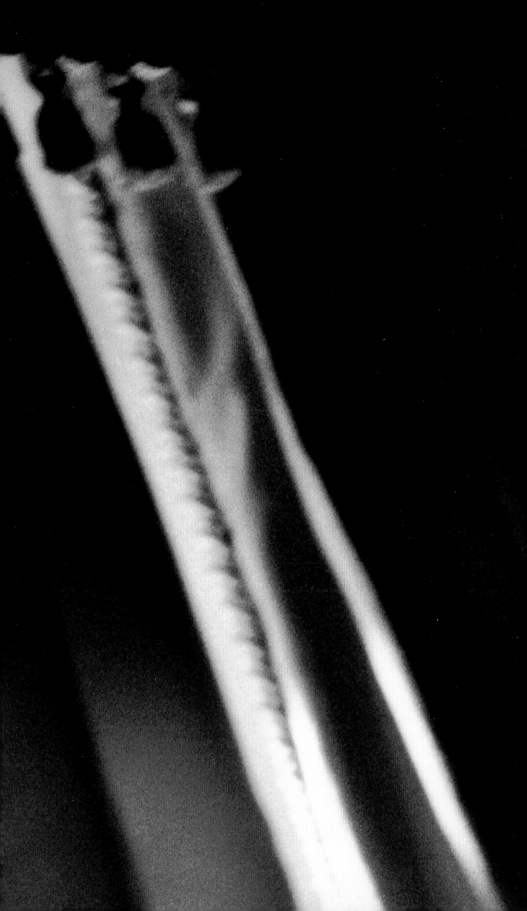

Mourning Hood Mask. Brazil, Upper Amazon River, Tocuna. Painted bark cloth and fiber. Wearing this dance costume, the dancer "puts on" the tribe: moieties are vertically divided, and generations are horizontally marked. ☙ *Rattle in the Form of a Mythic Raven*. Alaska, Tlingit. Painted wood with string. ☙ *Spindle Whorl*, late 18th or early 19th century. British Columbia, Salish. Wood. The decoration is concealed from human view and intended for the spirits only.'

"Witnesses to a Surrealist Vision," exh. brochure (Houston: The Menil Collection, 2001) [3–4, 6–7].

24

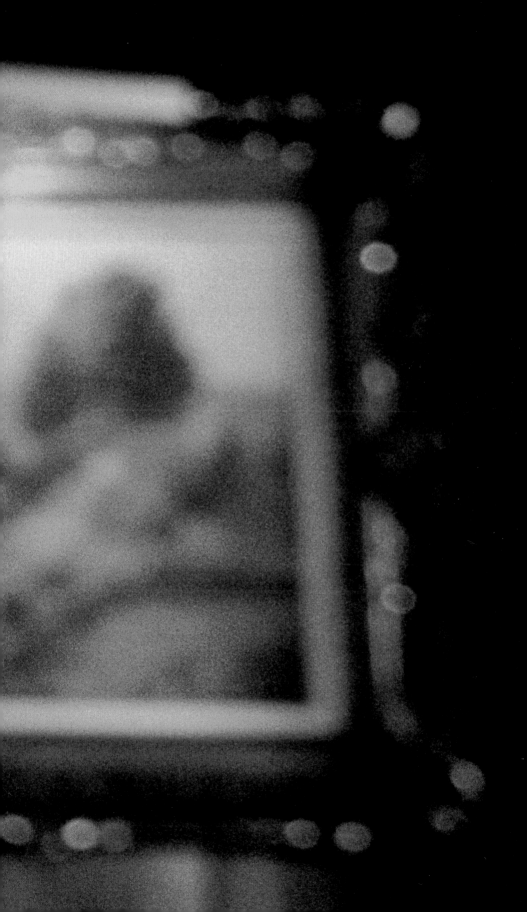

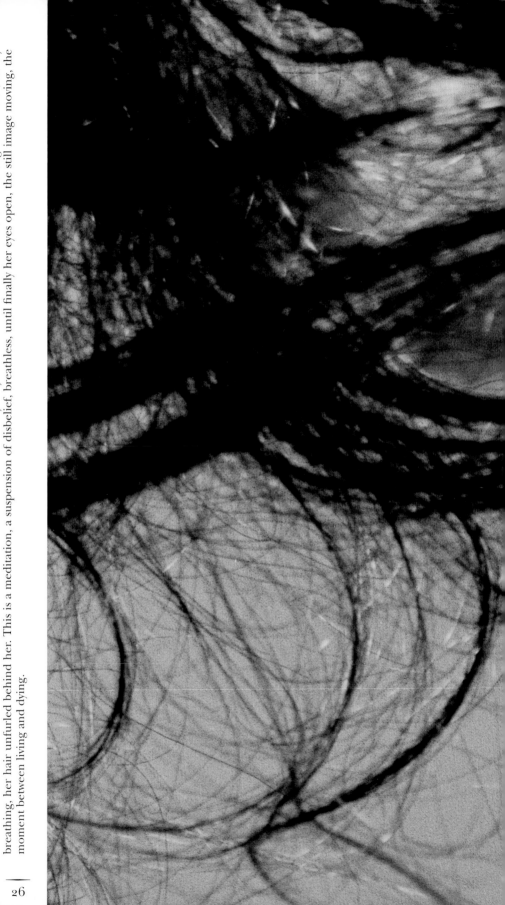

Shadows of the chandelier slide down the wall. The dark maw of the arched doorway only leads farther inward. This is true knowledge. She floats, barely breathing, her hair unfurled behind her. This is a meditation, a suspension of disbelief, breathless, until finally her eyes open, the still image moving, the moment between living and dying.

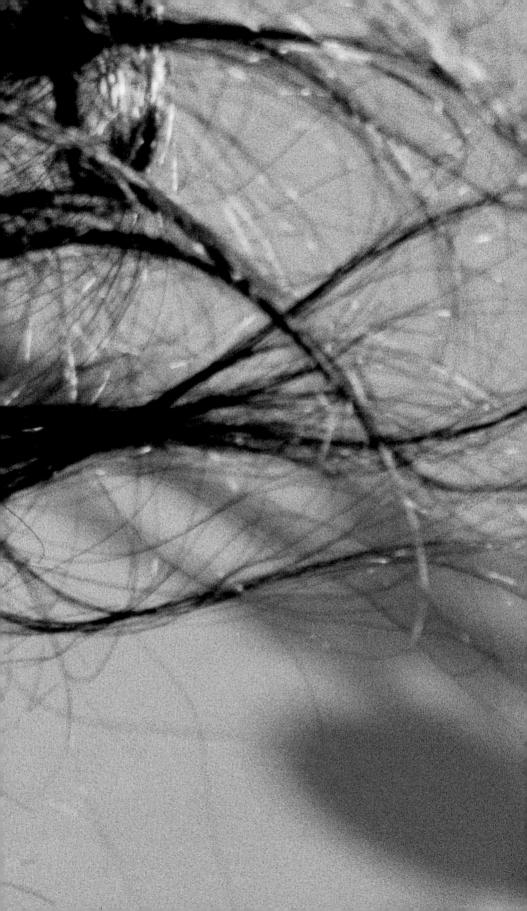

'True knowledge comes down to vigils in the darkness: the sum of our insomnias alone distinguishes us from the animals and from our kind. What rich or strange idea was ever the work of a sleeper? Is your sleep sound? Are your dreams sweet? You swell the anonymous crowd. Daylight is hostile to thoughts, the sun blocks them out; they flourish only in the middle of the night.'

E. M. Cioran, "The Decor of Knowledge," in *A Short History of Decay*, trans. Richard Howard (London: Quartet Books, 1949), 147.

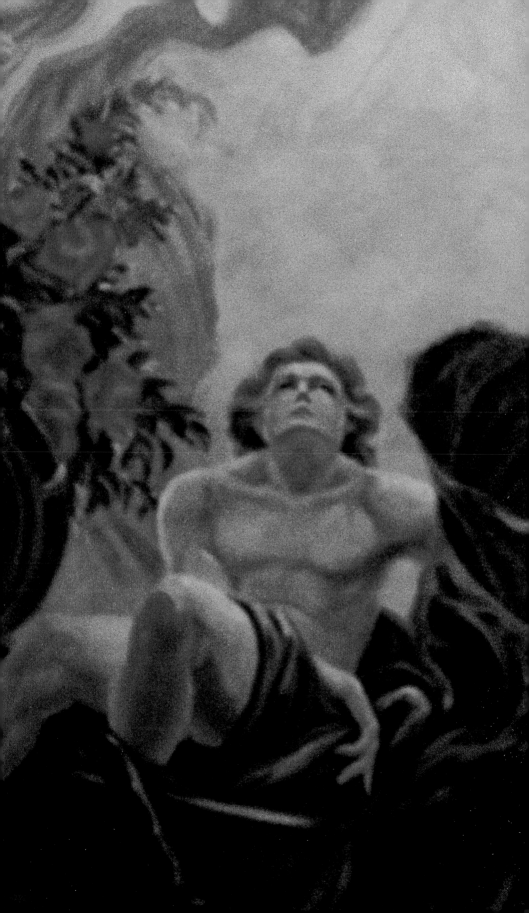

Charlatans will tell you that the photograph can capture the spirit and will show you plenty of doctored images to prove it. I only assert that the photograph is a medium that permits the spirit to reenter the world through a facsimile of its previous self. The photograph is as much about absence as presence. She could sense rather than see the flickering images of the daguerreotypes against the wall, but there was nothing else. As time moved on, there was not the slightest sensation of anything out of the ordinary.

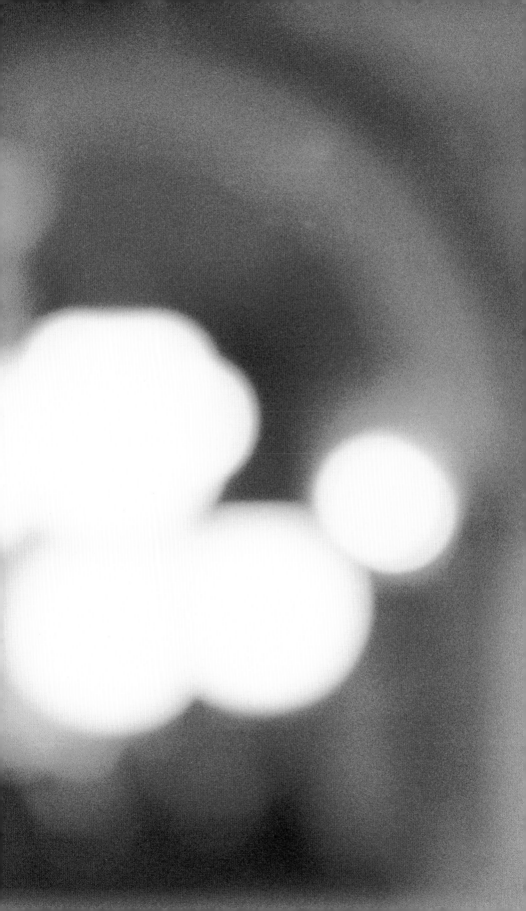

'Back again into the moving unquiet depths.
Room within room, the house divided itself endlessly as it moved inward toward no fixed element.'

Daphne du Maurier, *Rebecca* (1938) (London: Arrow Books, 1992), 396.

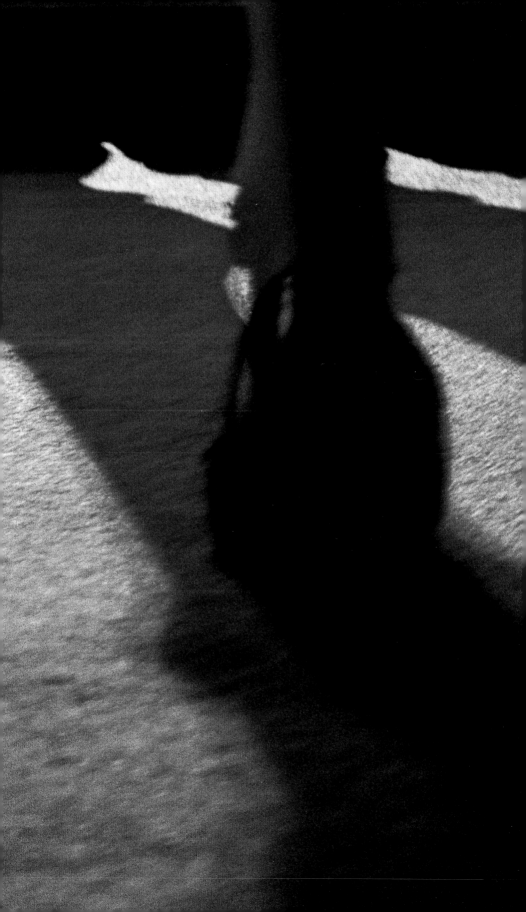

'Lost in my labyrinth I see no truth, only the / foggy walls of evil press upon me. / Lost in my labyrinth I see no truth. / O Innocence you have corrupted me, / which way shall I turn?'

Myfanwy Piper, libretto after a story by Henry James, for Benjamin Britten, *The Turn of the Screw* (New York: Boosey & Hawkes, 1954).

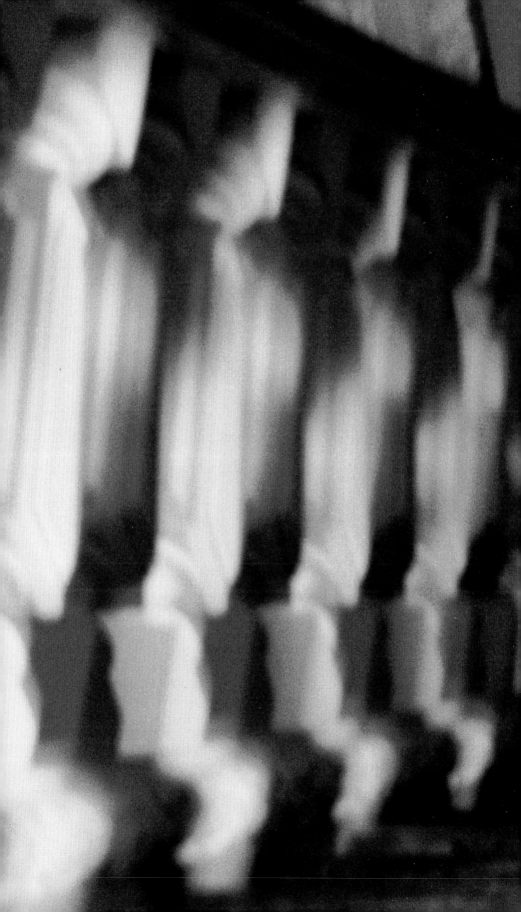

'I lay awake on my bed, but differently than in the daytime; I felt like the figure on its coffin lid. It's very hard to describe, but when I reflect on it it was as if I had been turned inside out. I was no longer a solid, space-filling form, but something like a depression in space. The room was not hollow but was permeated by a substance that doesn't exist in the daytime, darkly transparent and darkly transpalpable—I, too, was made of it.'

Robert Musil, "The Blackbird" (1935), in *Selected Writings*, ed. Burton Pike, trans. Thomas Frick and Wilhelm Wiegandt (New York: Continuum, 1986), 326–99.

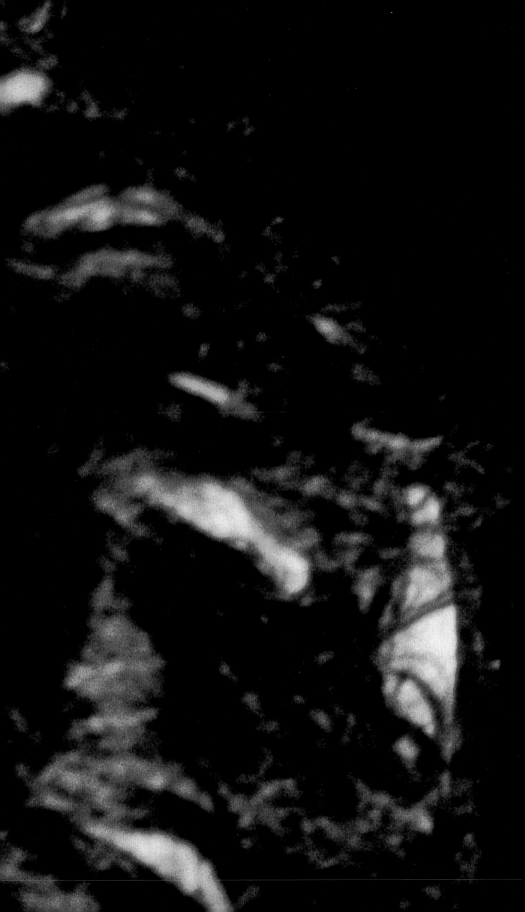

No Shadow? No Mystery?

NIALL MACKENZIE

IN HIS PREFACE to *The Marble Faun*, Nathaniel Hawthorne claimed a handicap on behalf of the American artist, which many of his successors have cited with approval. "No author," he wrote, "without a trial, can conceive of the difficulty of writing a Romance about a country where there is no shadow, no antiquity, no mystery, no picturesque and gloomy wrong, nor anything but a commonplace prosperity, in broad and simple daylight, as is happily the case with my dear native land."[1] *The Marble Faun* was published in 1860, and even if the condition of "commonplace prosperity" were ever as widely experienced as Hawthorne supposed, that year's presidential election was to set in motion events that would put the United States on a fast track to the accumulation of shadows and gloomy wrongs. As Anna Gaskell's *half life* opens at the Menil, we look ahead, next year, to St. Petersburg's tercentenary—an occasion that reminds us that that great and haunted capital of European civilization is actually a younger city than Boston, the metropolis of Hawthorne's native Commonwealth. The United States is no longer, by any sober historical reckoning, a young society, but one entering a wised-up, slightly emphysemic midlife crisis. Along the way, the myths that commonly support and extend the idea of eternal American youth have been questioned or counterexampled for

as long, in most cases, as they have been articulated. A tradition of skeptical historians, starting with Charles and Mary Beard, has exposed the night side of the American self-attributions of innocence, success, and social felicity; the idea of a culture without irony finds eloquent rebuttal (as John Gray recently pointed out) in such figures as Ambrose Bierce, H. L. Mencken, Dorothy Parker, and Mae West; and the quintessentially American genre of film noir stands as a crushing rebuke to the idea of a culture lacking the tragic sense.[2]

In the above observations, which, I will suggest, have a contextual relevance to *half life*, I have referred to novelists, historians, journalists, raconteurs, and filmmakers—all practitioners of one form or another of narrative art. It is natural that one's thoughts should move along such channels when contemplating Gaskell's work, which here, as in earlier projects, imposes on the viewer a compulsion to weave a narrative fabric around the clues and suggestions she offers. Her pictorial signatures—the skewed angles, strategic omissions, and seductive arrangements of light, shadow, and color—give each image a rich formal autonomy, but at the same time, paradoxically, sharpen that desire for narrative expansion.

Here, as in earlier projects, the literal-minded viewer will be defeated in trying to reduce the pictures to any clear-cut isomorphic correspondence with the text, which they take as their starting point. The source in this case is Daphne du Maurier's *Rebecca* of 1938. This is the tale of an ingénue who marries, abroad, a worldly middle-aged patrician and accompanies him back to his ancestral estate in Cornwall, only to find the place stamped with the memory of his dead first wife—Rebecca—whose influence, mediated through a

malevolent servant and assisted by the heroine's insecurities, hamstrings their marriage and impels her to the brink of suicide. Two-thirds of the way through the book, du Maurier delivers a walloping surprise, the effect of which is to put a new complexion on everything that went before, and to introduce a shift in genre. For the last part of the story, we are no longer in the half-lit region of spooky footstep-sounds and dimly perceived shapes vanishing around corners, the region we had occupied, in exquisite discomfort, throughout the first part. The final third savors of the whodunit and the courtroom drama, where events are altogether too well lit, where the heroine's and our states of knowledge are all too damningly complete (or so we imagine), and where the forces of justice, blackmail, and fearless guilt encounter one another in a nerve-stretching climax.

The pictures in *half life* derive, if that is the word, from the spooky part of Rebecca, and readers of the novel will recognize the bed and the stairway and appreciate their disquieting associations. But while these pictures allude in a loose way to certain features of du Maurier's creation, and evoke its atmosphere of "furtive unrest,"[3] they are not equivalents whose meaning or referential sweep are confined to their connections with the source text. Other influences, other voices crowd in upon us. Gaskell's doorways and her paneled, portrait-lined corridors lead to rooms we remember from other books or have visited in our dreams, and they echo with footfalls, stair-creaks, and whispers that import the presence of spirits other than that which torments du Maurier's heroine.

The old house or castle whose decaying splendor and mazelike sprawl of interior spaces awaken contrary, child-like instincts of curiosity and irrational fear is a familiar set-

ting of Gothic fiction. (That Gaskell should have found in her American locations the right materials to create these pictures is itself a sign of the advancing maturity of the "New World.") In Hawthorne's day, American writers tended to rummage abroad for settings when they were writing in the Gothic vein—or indeed to go abroad for inspiration. Hawthorne's rather chilly "Romance" *The Marble Faun* germinated as he was living in Tuscany in a house he described to a friend as follows: "[It] is big enough to quarter a regiment, insomuch that each member of the family, including servants, has a separate suite of apartments, and there are vast wildernesses of upper rooms into which we have never yet sent exploring expeditions. At one end of the house there is a moss-grown tower, haunted by owls and by the ghost of a monk."[4] Just as Gaskell's previous bodies of work have displayed her eloquence with the vocabularies of the fantastic and the uncanny, so does the present series demonstrate her mastery of the conventions and psychological effects of the Gothic.

It is, moreover, the subtlest and quirkiest manipulators of the Gothic tradition whose influences press most forcefully upon the present series—Edgar Allan Poe, and above all Henry James. In James's novel *The Awkward Age* (1899), an adolescent girl saunters one July afternoon outside a house much like the one Gaskell evokes in these pictures:

> Find[ing] the place unoccupied as yet by other visitors, [she] stood there awhile with an air of happy possession. (What a difference daylight makes!) She moved from end to end of the terrace, pausing, gazing about her, taking in with a face that showed the pleasure of a brief independence the combination of delightful things—of old rooms

with old decorations that gleamed and gloomed through the high windows, of old gardens that squared themselves in the wide angles of old walls, of wood-walks rustling in the afternoon breeze and stretching away to further reaches of solitude and summer. The scene had an expectant stillness that she was too charmed to desire to break; she watched it, listened to it, followed with her eyes the white butterflies among the flowers below her, then gave a start as the cry of a peacock came to her from an unseen alley.[5]

A few pages later, on the same terrace but now within a busier scene, another character perceives a contrast between this girl and her younger playmate to whom the world does not yet seem to have intimated any of its secrets: "Both the girls struck him as lambs with the great shambles of life in their future; but while one, with its neck in pink ribbon, had no consciousness but that of being fed from the hand with the small sweet biscuit of unobjectionable knowledge, the other struggled with instincts and forebodings, with the suspicion of its doom and the far-borne scent, in the flowery fields, of blood."[6] That sentence would make as good an epigraph as any I can think of for Gaskell's work to date, with its concentration on the psychology of young women, its themes of duality, foreboding, menace, and objectionable knowledge discerned amid trappings of childhood.

The Turn of the Screw (1898), the James tale that bears most directly on *half life* (supplying several visual referents), exemplifies the species of ambiguity that Gaskell translates, as no one else quite has, from the literary realm to the visual. James does not give us either-or problems and challenge us to figure out the solution; no amount of textual sleuthing

will determine if the ghosts in *The Turn of the Screw* are real, or if our suspicions about the governess's state of mind were warranted all along. But it is not impossible for both readings to be true; nor, at the level of narrative literality, are they reconcilable within some larger whole. The distinctive feature of Jamesian ambiguity is that it reveals systems of clues that point to multiple, mutually exclusive hypotheses, which coexist in equilibrium. They do not cancel each other out, and no one meaning is ever allowed a decisive advantage over its rival or rivals. The resulting tension of incompatible alternatives occupying the same hermeneutic space will be familiar to anyone who has lingered for long in front of Gaskell's *wonder* series (1996–97), for instance, or *hide* (1998), trying to distinguish innocence from its shadow. It is the mark of an artist serenely in command of the possibilities of her media and possessing rare directorial intelligence that Gaskell can reproduce the effect of literary ambiguity in sequences of still images and in films—employing photographic technologies, which retain a built-in commitment to reductive literalism.

As with the disrespect for linear chronology evinced in her films and image sequences, Gaskell's hospitality to contrary interpretations links her work to the experience of dreaming. Few artists have been able to render so deftly the peculiar conditions of sleep—metamorphosis, mutability, the Sisyphean thwarting of desire, the transformation of unknown places and people into familiar ones, the vivid sensation of logic with no trace of its substance. In this sense, Gaskell's dialogue with Lewis Carroll across a gulf of time was as auspicious a matchup as Botticelli's with Dante or Hans Bellmer's with Georges Bataille. Gaskell's work dwells in the mind somewhere between our memories of child-

hood and our dreams. That is how far into the physical structure of the brain her work reaches. And that is why, for all its technical virtuosity and sophisticated cultural positioning, it can hit you like a tire iron.

It is fitting that *half life*, whose spark was a book by a female writer unjustly downgraded for reasons of gender and genre, should open at The Menil Collection, a place where the late Dominique de Menil's influence is as benignly pervasive as, in du Maurier's novel, Rebecca's is insidiously so. The awareness of a matrilineage of collectors, artists, and educators, informing and enriching current practice, is a powerful factor in the contemporary art world. The names Guggenheim and Cone, in addition to Menil, are a ready indication of how much American art history owes to strong-minded female collectors. But behind those big names stretches a hinterland of mostly anonymous women who sustained a kind of artistic underground throughout the centuries enumerated by historians of European and American art.

Photography, the fairy tale, folklore, and the novel—all elements in Gaskell's complex structure of allusion—are media in which women were able to stake an early and enduring claim. Because the novel at its debut was perceived to be lacking in consequence as a literary form, it provided a field that was hospitable to women as well as men; Gothic fiction, in fact, enjoys the distinction of having been largely invented, in the eighteenth century, by women—Ann Radcliffe, whose *Mysteries of Udolpho* (1794) is mentioned in *The Turn of the Screw*, Clara Reeve, and others. Both popular and emerging art forms, because they are disregarded by the policemen of the academic canon, have historically been more penetrable by women than established art forms. The

exhilarating scholarship of Anne Higonnet has shown this to have been the case with Berthe Morisot's involvement with the Impressionist movement,[7] and it is also true of photography, a medium in which women have occupied a pioneering position since the nineteenth century.

Gaskell's recognition of this heritage underpins her achievement. Such an achievement argues that the "broad and simple daylight" that Hawthorne saw falling on his native land is no longer ignorant "of the secrets of the world," as James said in relation to Hawthorne's writing, "and . . . of the weariness of shining."[8] Anna Gaskell has added a new wilderness of rooms to the house of American art.

NOTES

1. Nathaniel Hawthorne, *The Marble Faun: or, The Romance of Monte Beni* (1860), The Centenary Edition of the Works of Nathaniel Hawthorne, vol. 4 (Columbus: Ohio State University Press, repr. 1971), 3.

2. John Gray, contribution to forum "What We Think of America," *Granta* 77 (spring 2002), 37.

3. Daphne du Maurier, *Rebecca* (1938) (London: Arrow Books, 1992), 8.

4. Quoted in Henry James, *Hawthorne* (1879), Pocket edition (London: Macmillan, 1909), 164.

5. Henry James, *The Awkward Age* (1899), ed. Vivien Jones (Oxford: Oxford University Press, 1984), 134.

6. Ibid., 159.

7. Anne Higonnet, *Berthe Morisot's Images of Women* (Cambridge, Mass.: Harvard University Press, 1992).

8. James, *Hawthorne*, 12.

Plates

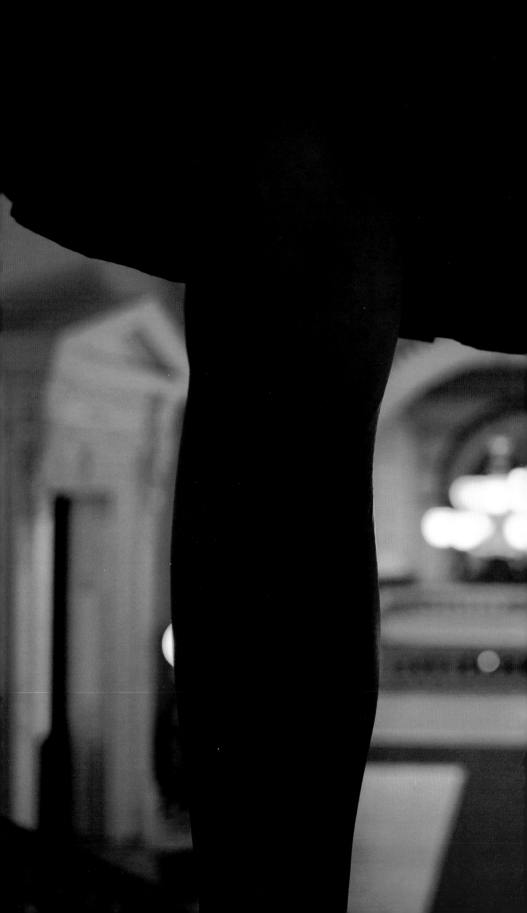

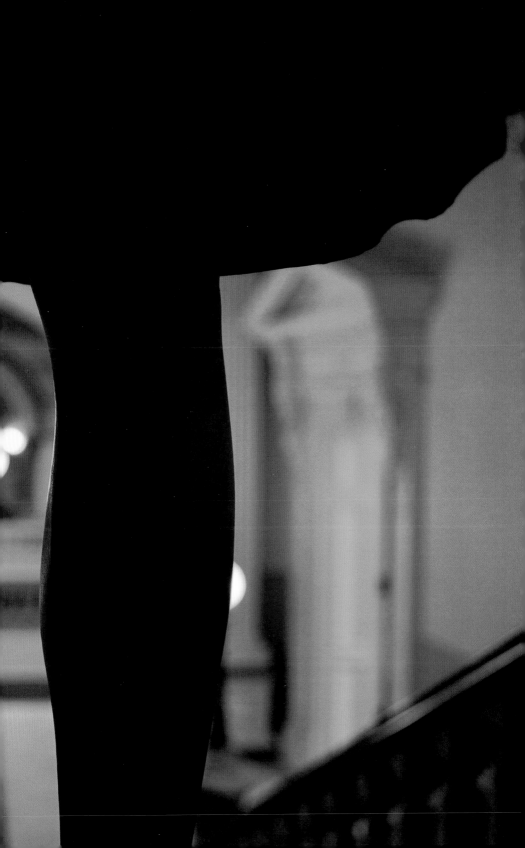

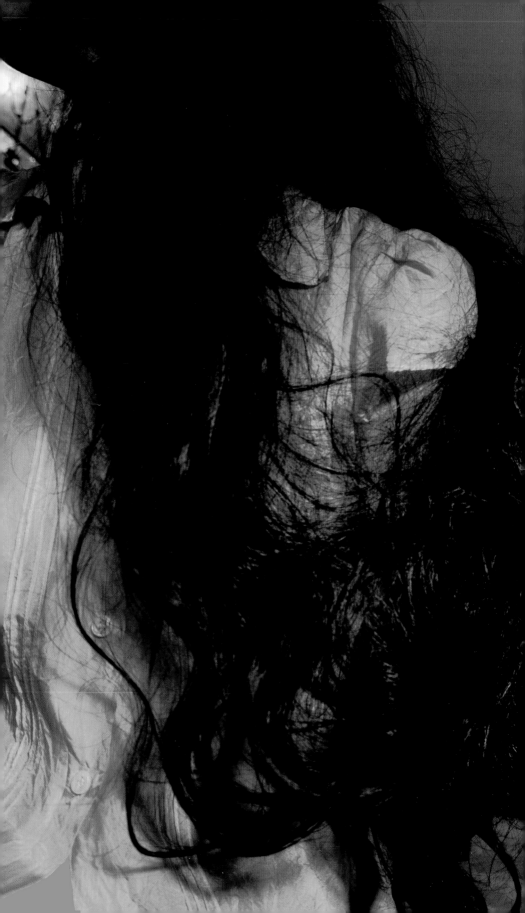

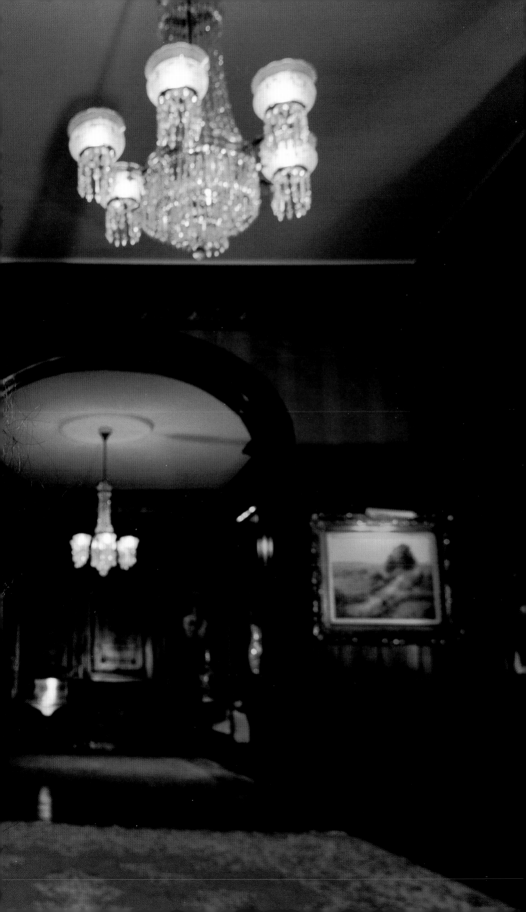

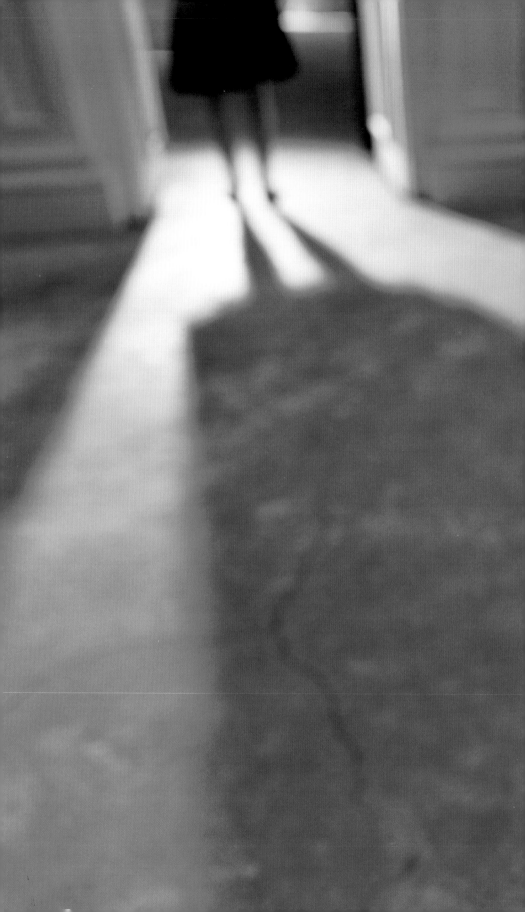

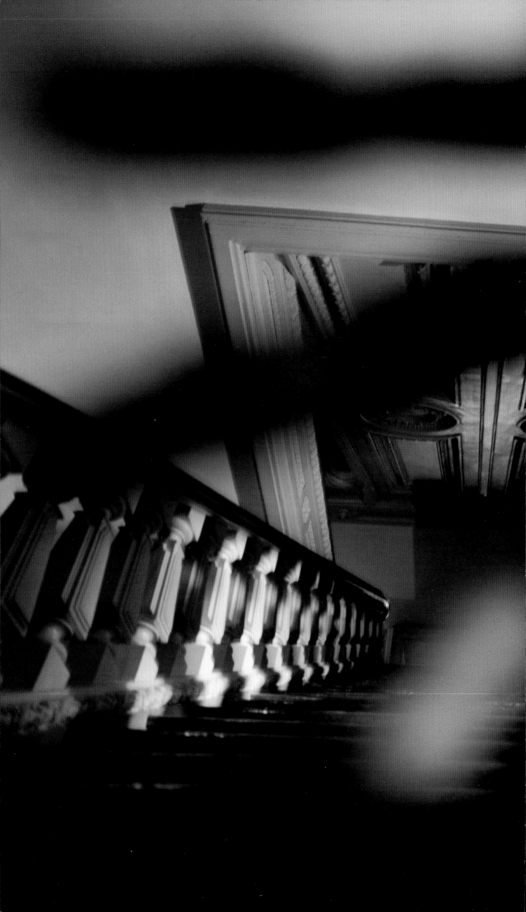

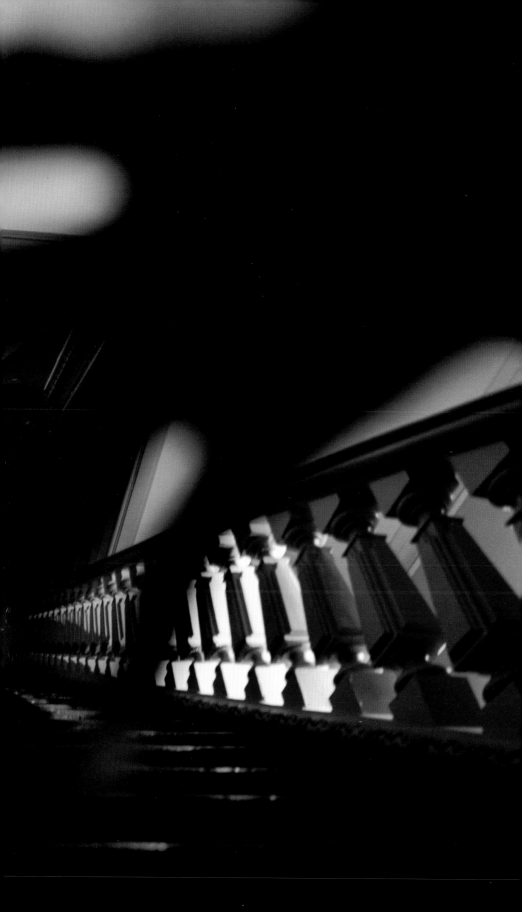

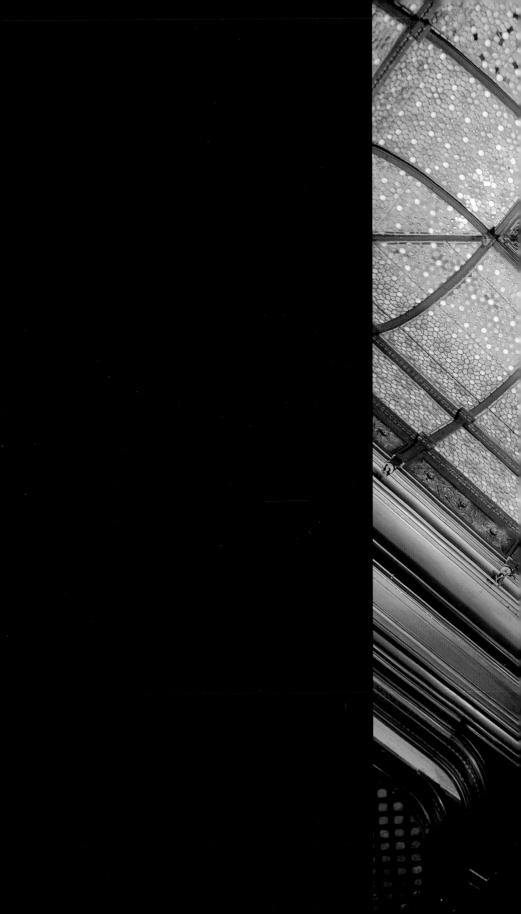

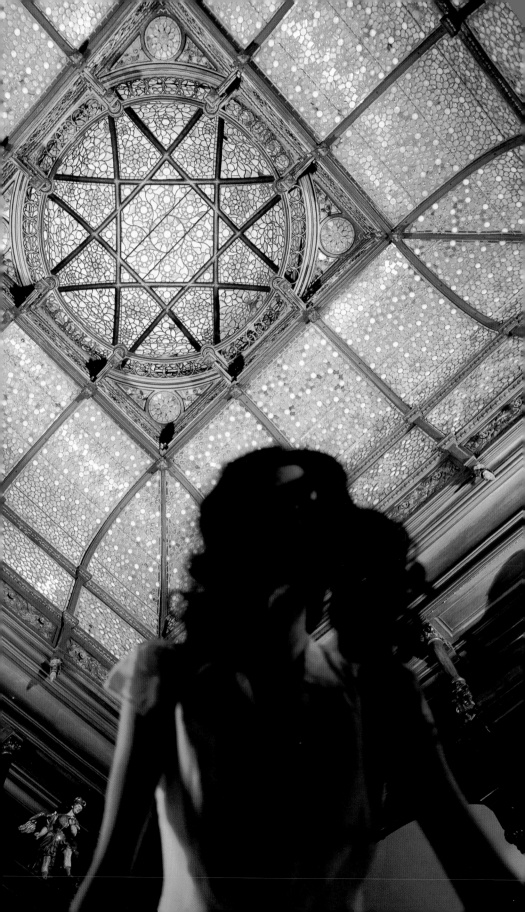

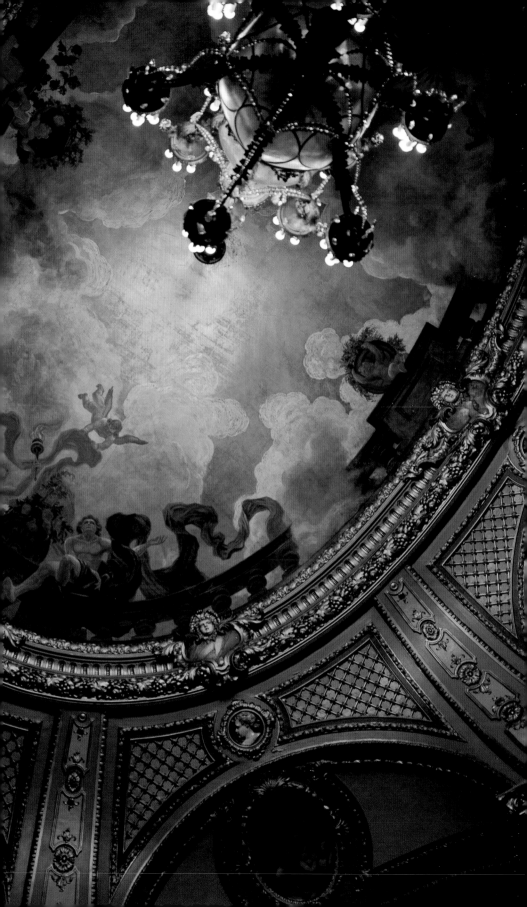

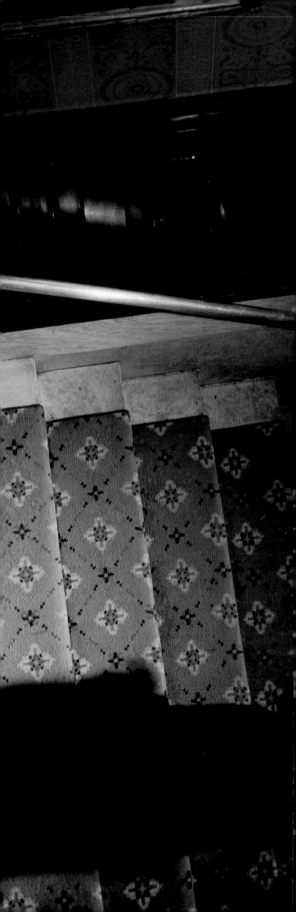

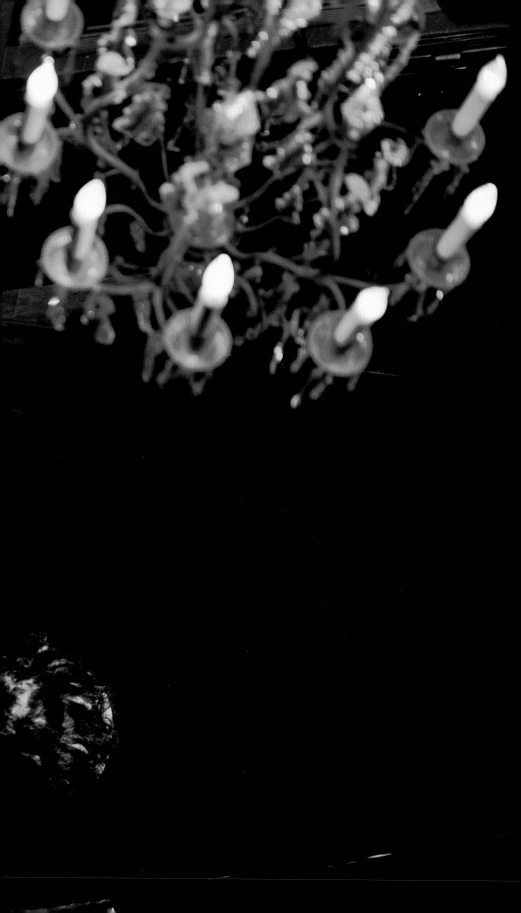

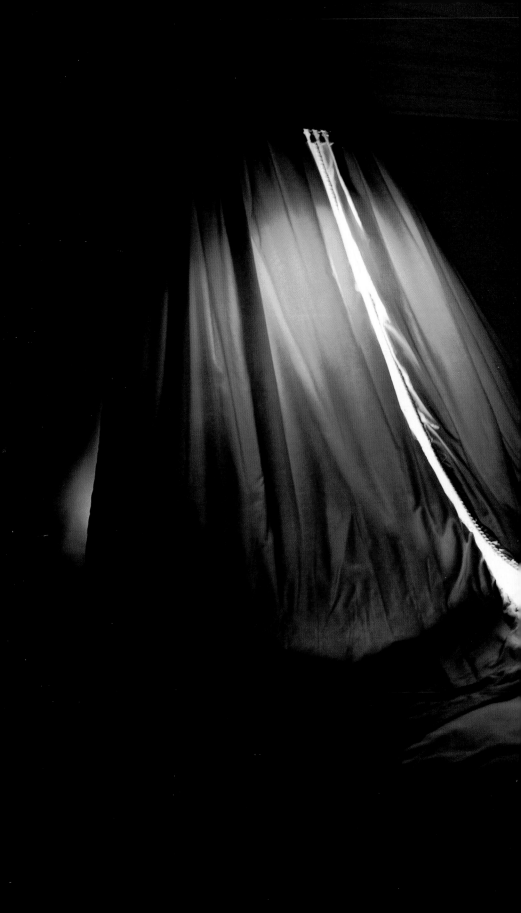

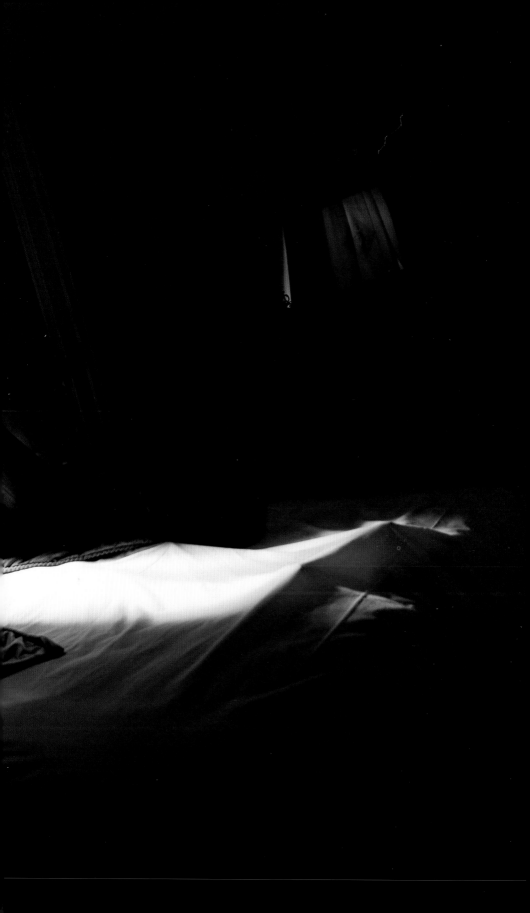

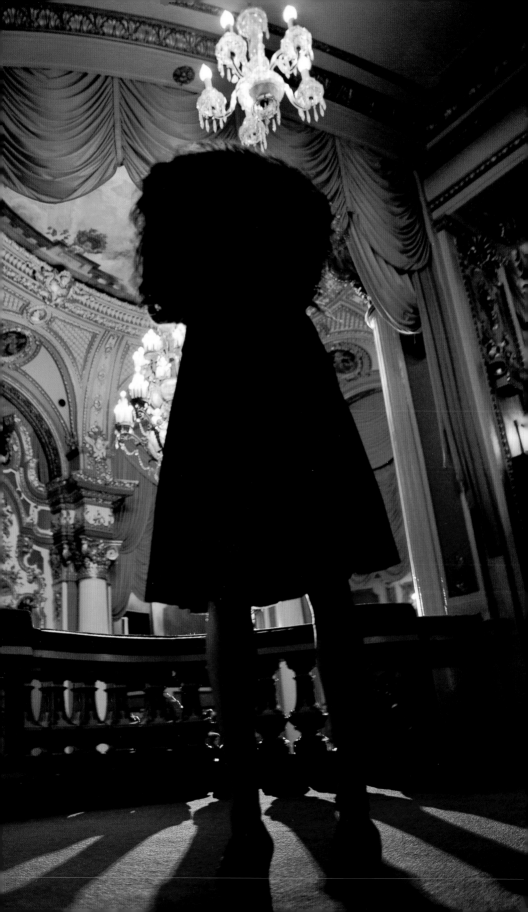

Interview

August 2002

MATTHEW DRUTT: *I have to ask first about Iowa. It has clearly been formative to you in so many regards. How so, and why do you return often to work there?*

ANNA GASKELL: My imagination was born in Iowa. Fortunately, I've got such a strong sense of place that I'm able to drag a little bit of Iowa with me wherever I go.

My mother was an evangelical Christian. As children, my brothers and I would join her on wild pilgrimages throughout the Midwest attending tent meetings, where we would watch miracles being performed, people speaking in tongues, healing by touch, surrounded by a belief in the impossible. I don't remember anything strange in all of this, but more a feeling of excitement and a security in the faith that I felt from everyone there.

My work moves around and through many different stories and characters, but at the heart of it all, it's about the suspension of disbelief, the possibility of the impossible, the absence of doubt, the completeness of faith.

Why do you forego the trappings of a conventional studio (fixed location, assistant, etc.)?

I carefully choose an environment to work in that allows the possibility of transforming itself into an imaginary world. Whether it's an interior or an exterior, I need to be able to enter the place and hear "once upon a time . . ." in my head.

In the photographs for the Menil, I wanted to imagine a mid-nineteenth-century house composed from various different locations in Manhattan. I specifically chose a number of public spaces in the city that could somehow alter or transform into a more private space—a house or a home.

How do you develop your subjects, and are you able to work on more than one body of work at a time?

I rarely work on more than one body of work at a time. I read, read, read to search for the perfect story.

Drawing has always been an important, if less overt, part of your working process. Does this function like scene treatments or storyboards, which plot certain ideas into visual correlations?

I wouldn't really describe my drawings as scene treatments or storyboards. They're another way of dealing with my frustration with the stillness of photography, and the impossi-

bility of moving, bending, or disfiguring a body to extremes within that medium. The drawings allow me to exaggerate some ideas that can be edited and revised before I take any photographs. I also enjoy the activity and immediacy of drawing.

—⁂—

Having initially developed a body of photo-based work celebrated for its cinematic look and feel, you have recently become more involved with the moving image as a primary medium parallel to your still work. How did this change come about, and has it had any impact on the way in which you approach still images?

I made a few films while I was in college, so it was always part of my practice. I think my more recent preoccupation with film comes, once again, from a frustration with still images, which by nature cannot translate movement. For example, my first film, *Floater* [1995], pictures a suicidal Ophelia floating in a pool of water, undecided whether to drown or save herself. The sequence is presented as an endless loop, emphasizing the character's relentless indecision. This idea—involving a temporal aspect—is clearly more suited to film than still images.

—⁂—

Is there a stronger relationship between the still and moving images in the Menil show than in past bodies of work?

Previously, my film and photographic works were independent of one another. For the exhibition at the Menil, I

finished the film piece first, at least conceptually. I should say here, though, that I am just as irritated with making a moving image as I am with a still photograph. When making a film I try to steer clear of creating anything like an excerpt from a movie or a mini-movie. It's critical to me to fight the idea of linear narrative while choosing to work in a medium in which linearity is inherent.

How is the strategy of open narrative in your art better served by film than photography?

I want viewers to be seduced into a scenario or story in which they find themselves suddenly caught up in the same trap as that of the character they are watching. The films are presented as continuous loops, so the viewers and the character find themselves repeatedly snagged as each cycle of the film re-presents the same challenge, always unresolved.

The film work really does go round and round and round and round.

Having initially decided that this would be a film project, what compelled you to go further and create a group of photographs along with it?

After I finished the film, I felt there were possibilities for another kind of story. Once again, I was not interested in a linear narrative, but something closer to an idea of the type of space that this character might inhabit.

The film is a portrait and the photographs are faceless. This is not to say that I think of the film as being the missing "head" of the photographic body. I prefer the idea that you or I, or any viewer, might imagine numerous faces or bodies that could inhabit the ghostlike figure in the photographs.

What has the context of The Menil Collection offered in the way of inspiration or a specific line of thought for this project?

I always wanted to make work around a ghost story. Henry James's *The Turn of the Screw*, the Winchester Widow, Edgar Allan Poe's "The Tell-Tale Heart," and Daphne du Maurier's *Rebecca* are all stories that I have carried around with me for some time, waiting for the right situation in which to both take them apart and tie them together.

After visiting the museum, I liked the idea of Dominique de Menil still being very present, somehow lurking around, manipulating the board members, and influencing curators and anyone else in power, steering decisions to go the way she would have intended them to. There may also be an undercurrent of fear in this scenario, as Dominique watches over people padding carefully around her space—aware of her vibrating presence, larger than they are, larger than life.

Why is it misguided for audiences or critics to try and connect too many dots between your sources and the finished product?

The stories and events that I choose to use as jumping-off points are simply that. They are only a part of what goes into the work, and are perhaps a useful reference for viewers. For example, the pieces for the Menil are informed by many stories, the most explicit of which would be *Rebecca,* but neither the film nor the photographs are illustrations of that story or any particular story.

Trying to combine fiction, fact, and my own personal mishmash of life into something new is how I make my work. Into all of this, I try to insert a degree of mystery that ensures that the dots may not connect in the same way every time.

———

Stills

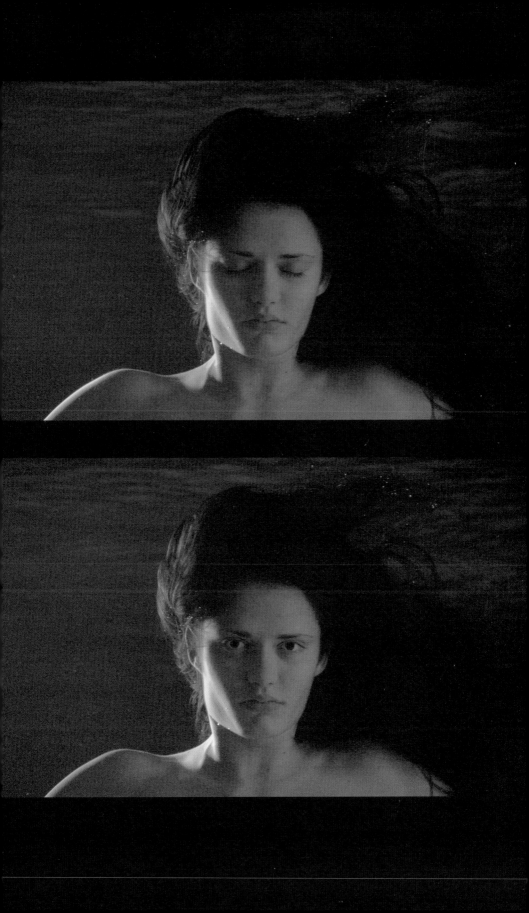

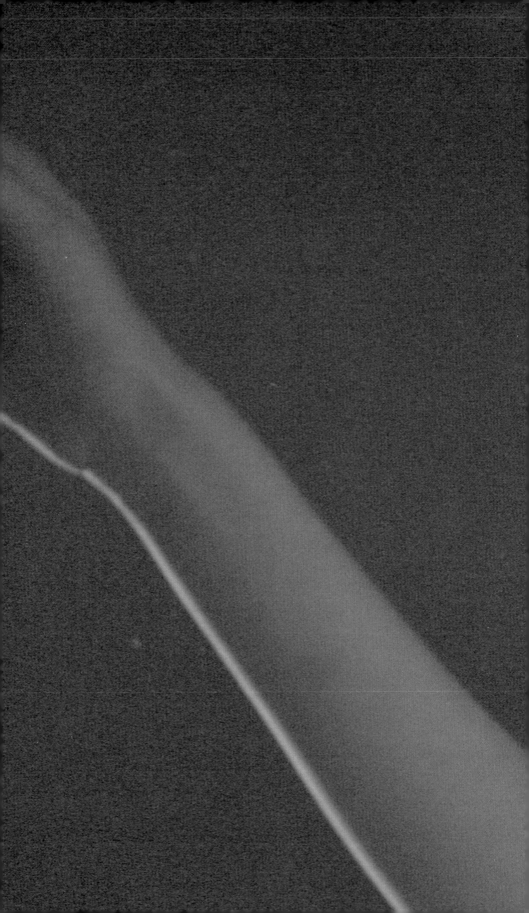

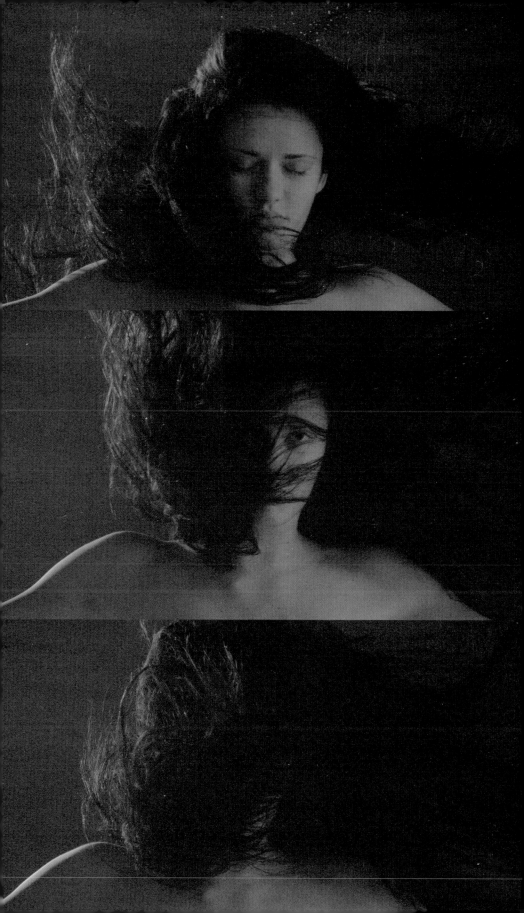

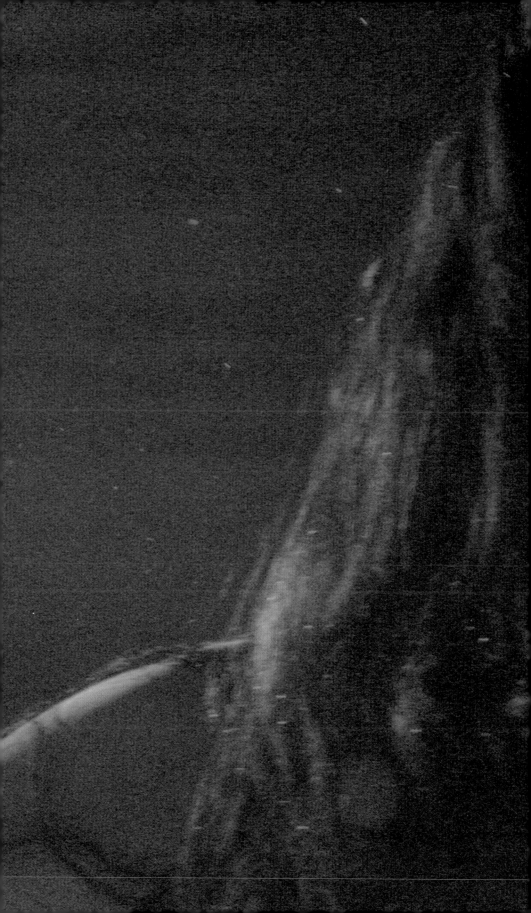

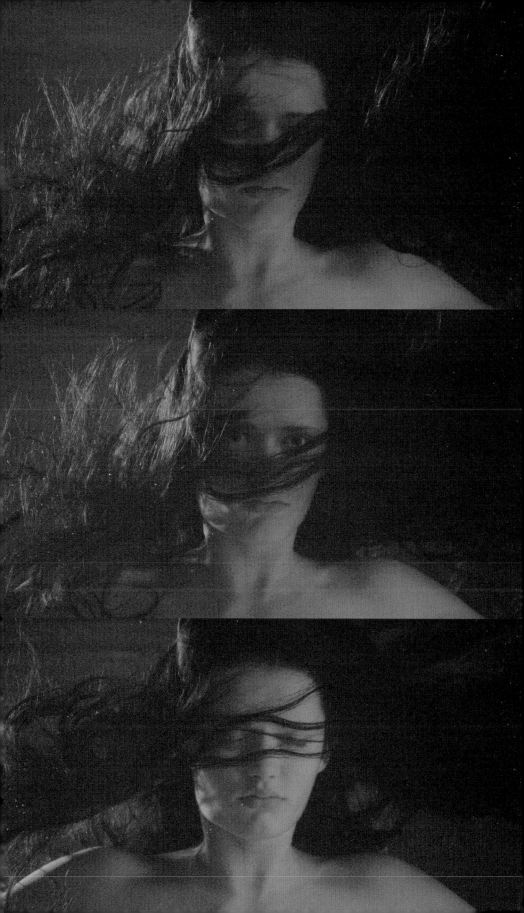

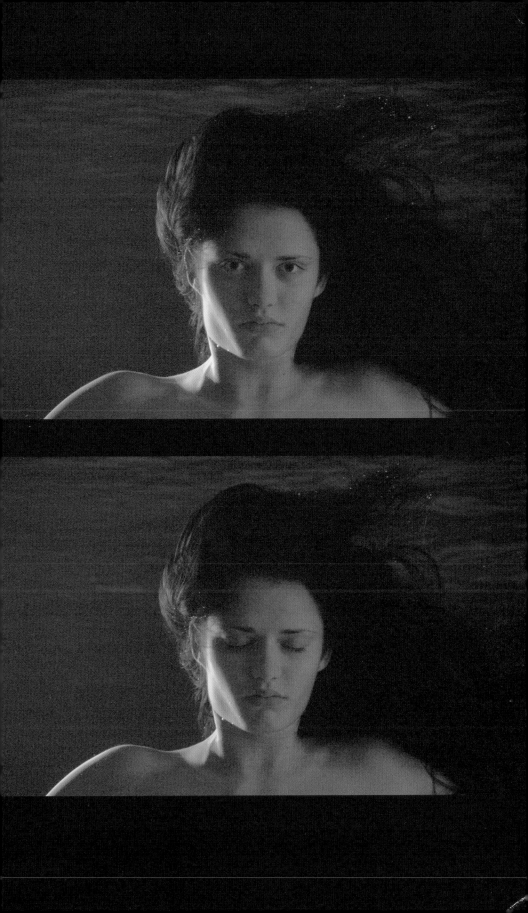

Anna Gaskell: half life

The Menil Collection
September 27, 2002–January 12, 2003

CHECKLIST OF THE EXHIBITION

Untitled # 88 (half life), 2002
C-print, 50 x 60 in.

Untitled # 89 (half life), 2002
C-print, 40 x 50 in.

Untitled # 90 (half life), 2002
C-print, 40 x 50 in.

Untitled # 91 (half life), 2002
C-print, 60 x 70 in.

Untitled # 92 (half life), 2002
C-print, 30 x 40 in.

Untitled # 93 (half life), 2002
C-print, 70 x 60 in.

Untitled # 94 (half life), 2002
C-print, 20 x 24 in.

Untitled # 95 (half life), 2002
C-print, 40 x 50 in.

Untitled # 96 (half life), 2002
C-print, 50 x 60 in.

Untitled (half life), 2002
DVD installation, dimensions vary, 21 min.
Produced by The Menil Collection
Edition 1/3
The Menil Collection
Gift of the artist and Casey Kaplan

Biography

Born 1969 in Des Moines, Iowa
Lives in New York

EDUCATION

1995
M.F.A., School of Art, Yale University, New Haven, Connecticut

1992
B.F.A., The School of the Art Institute of Chicago, Illinois

1990
Bennington College, Vermont

AWARDS

2002
Nancy Graves Foundation Grant

2000
The Citibank Private Bank Photography Prize

SOLO EXHIBITIONS

2003
Galerie Gisela Capitain, Cologne, Feb. 14–Apr. 12

2002
half life, White Cube, London, Dec. 12, 2002–Jan. 25, 2003
half life, The Menil Collection, Houston, Sept. 27, 2002–Jan. 12, 2003
Anna Gaskell, Yvon Lambert Le Studio, Paris, June 1–14
resemblance, Addison Gallery of American Art, Andover,
 Massachusetts, Jan. 19–Apr. 21

2001

resemblance, Des Moines Art Center, Iowa, Dec. 8, 2001–Mar. 3, 2002
resemblance, Castello di Rivoli–Museo d'Arte Contemporanea, Turin, Oct. 17, 2001–Jan. 13, 2002
resemblance, Casey Kaplan, New York, Oct. 12–Nov. 10
remarkable places, Kölnischer Kunstverein, Cologne, Aug. 17–Sept. 30
future's eve, New Langton Arts, San Francisco, Apr. 4–May 5

2000

by proxy, Aspen Art Museum, Colorado, Aug. 1–Oct. 15

1999

by proxy, Casey Kaplan, New York, Nov. 19–Dec. 18
Sally Salt says..., Galerie Gisela Capitain, Cologne, Oct. 29–Dec. 18
hide, White Cube, London, Feb. 5–Mar. 6

1998

Anna Gaskell, Museum of Contemporary Art, North Miami, Florida, Oct. 18–Dec. 6; traveled to Museum of Modern Art, Oxford, England, Apr. 18–June 27, 1999; Astrup Fearnley Museet, Oslo, Aug. 19–Sept. 26, 1999; Hasselblad Center, Göteborg, Sweden, Oct. 30–Nov. 28, 1999

1997

wonder, Casey Kaplan, New York, Nov. 14–Dec. 20

SELECTED GROUP EXHIBITIONS

2003

Constructed Realities: Contemporary Photographers, Orlando Museum of Art, Florida, Mar. 8–May 18

2002

Photography Past/Forward: Aperture at 50, Aperture's Burden Gallery, New York, Oct. 21–Nov. 3; traveling 2003–6
Transformer, Porin Taidemuseo, Pori, Finland, Sept. 18–Oct. 11
Moving Pictures, Solomon R. Guggenheim Museum, New York, June 28, 2002–Jan. 12, 2003

Visions from America: Photographs from the Whitney Museum of American Art, 1940–2001, Whitney Museum of American Art, New York, June 27–Sept. 22

Realitetsfantasier, Post-Modern Art from the Astrup Fearnley Collection, Astrup Fearnley Museet, Oslo, May 4–Sept. 29

Stories. Erzählsstrukturen in der zeitgenössischen Kunst, Haus der Kunst, Munich, Mar. 28–June 23

Desiring Machines, Dorsky Gallery Curatorial Programs, Long Island City, New York, Mar. 24–May 12

2001

Emotional Rescue: The Contemporary Art Project Collection, Center on Contemporary Art, Seattle, Sept. 28–Oct. 28

32ème Rencontre internationale de la photographie, Arles, France, July 4–Aug. 19

Collection d'artistes, Collection Lambert, Avignon, France, June 30–Oct. 30; traveled to Galerie hlavního města Prahy, Prague, June 21–Sept. 16

Settings and Players: Theatrical Ambiguity in American Photography 1960–2000, White Cube, London, Mar. 9–Apr. 21

New Acquisitions from the Dakis Jouannou Collection, 1998–2001, Deste Foundation, Athens, Feb. 9–May 23

2000

Jahresgaben, Kölnischer Kunstverein, Cologne, Nov. 17, 2000– Jan. 30, 2001

Hypermental, Kunsthaus Zürich, Nov. 16, 2000–Jan. 21, 2001

The Astrup Fearnley Collection, Astrup Fearnley Museet, Oslo, Aug. 19–Sept. 26

Staged, Bonakdar Jancou Gallery, New York, May 4–June 3

ForWart, Banque Bruxelles Lambert, Brussels, Apr. 5–May 12

The Citibank Private Bank Photography Prize 2000, The Photographer's Gallery, London, Feb. 2–Mar. 24

1999

L'Autre Sommeil, Musée d'Art Moderne de la Ville de Paris, Nov. 17, 1999–Jan. 23, 2000

Auf der Spur. Kunst der 90er Jahre im Spiegel von Schweizer Sammlungen, Kunsthalle Zürich, Oct. 31–Dec. 27

Pop Surrealism, The Aldrich Museum of Contemporary Art,
 Ridgefield, Connecticut, June 7–Aug. 30
Generation Z, P.S.1 Contemporary Art Center, Long Island City, New
 York, Apr. 18–June 6
Unheimlich, Fotomuseum Winterthur, Switzerland, Mar. 27–May 24
Power X-Change, Galerie Gisela Capitain, Cologne, Mar. 20–Apr. 18
Photography: An Expanded View, Recent Acquisitions, Solomon R.
 Guggenheim Museum, New York, Feb. 22–May 16; traveled to
 Guggenheim Bilbao Museoa, Spain, July 24–Dec. 20
Sightings, Institute of Contemporary Arts, London, Jan. 10–Mar. 15
View One, Mary Boone Gallery, New York, Jan. 9–Feb. 7

1998
Global Vision, New Art from the 90s, Part III, Deste Foundation, Athens,
 Nov. 24, 1998–Jan. 30, 1999
Remix, Musée des Beaux-Arts de Nantes, France, Nov. 18–Mar. 5
I Love New York: Crossover of Contemporary Art, Museum Ludwig,
 Cologne, Nov. 6, 1998–Jan. 31, 1999
Anna Gaskell, Cecily Brown, Bonnie Collura, Janice Guy, New York,
 Jan. 29–Mar. 7

1997
Stills: Emerging Photography in the 1990s, Walker Art Center,
 Minneapolis, Nov. 28, 1997–Mar. 8, 1998
Projects–Installations, Opening Exhibition, P.S.1 Contemporary Art
 Center, Long Island City, New York, Oct. 27, 1997–spring 1998
Pagan Stories, apexart, New York, Oct. 16–Nov. 15
The Name of the Place, Casey Kaplan, New York, Jan. 10–Feb. 8

1996
Portraiture: Contemporary Photographs, White Columns, New York,
 Dec. 6, 1996–Jan. 12, 1997
Baby Pictures, Bravin Post Lee, New York, June 1–29

Books and Exhibition Catalogues

Aletti, Vince, and Louise Neri, *Settings and Players,* exh. cat. (London: White Cube, 2001)

Basualdo, Carlos, Francesco Bonami, et al., *Cream: Contemporary Art in Culture* (London: Phaidon, 1998)

Bonami, Francesco, and Hans Ulrich Obrist, eds., *Dreams* (Turin: Fondazione Sandretto Re Rebaudengo per l'Arte, 1999)

Clearwater, Bonnie, *Anna Gaskell,* exh. cat. (North Miami: Florida Museum of Contemporary Art, 1998)

Collection d'artistes (Avignon and Arles: Collection Lambert and Actes Sud, 2001)

Curiger, Bice, and Christoph Heinrich, *Hypermental,* exh. cat. (Zurich and Ostfildern: Kunsthaus Zürich and Hatje Cantz, 2001)

Dawson, Tim, and Emma Dexter, *Sightings: New Photographic Art,* exh. cat. (London: Institute of Contemporary Arts, 1998)

Fogle, Douglas, *Stills: Emerging Photography in the 1990s,* exh. cat. (Minneapolis: Walker Art Center, 1997)

Gaskell, Anna, *Anna Gaskell* (New York: powerHouse, 2001)

Golsorkhi, Masoud, and Andreas Laeufer, eds., *Tank: The Good Book,* vol. 3 (London: Tank Publications, 1999)

Harris, Melissa, ed., *Photography Past/Forward: Aperture at 50,* exh. cat. (New York: Aperture Foundation, 2002)

Jacobson, Karen, ed., *by proxy,* exh. cat. (Aspen: Aspen Art Museum, 2000)

Lammi, Teija, ed., *Transformer,* exh. cat. (Pori, Finland: Porin Taidemuseo, 2002)

Pélenc, Arielle, *Remix,* exh. cat. (Nantes: Musée des Beaux-Arts de Nantes, 1998)

Perrin, Marie-Thérèse, *Le Printemps de septembre* (Arles: Actes Sud, 2001)

Petre, Anne, and Sébastien Charpentiers, *ForWart,* exh. cat. (Brussels: Banque Bruxelles Lambert, 2000)

Poetter, Jochen, *I Love New York: Crossover of Contemporary Art,* exh. cat. (Cologne: Museum Ludwig, 1998)

Romano, Gianni, *Bloom: Contemporary Art Garden* (Milan: Gotham, 1999)

Rosenthal, Stephanie, *Stories. Erzählsstrukturen in der zeitgenössischen Kunst,* exh. cat. (Munich: DuMont, 2002)

Scherf, Angeline, *L'Autre Sommeil* (Paris: Musée d'Art Moderne de la Ville de Paris, 1999)

Schwartz, Sheila, ed., *resemblance: Anna Gaskell,* exh. cat. (Des Moines: Des Moines Art Center, 2001)

Seeholzer, Therese, Fiona Seidler, and Urs Stahel, eds., *unheimlich*, exh. cat. (Winterthur: Fotomuseum Winterthur, 1999)

32ème Rencontre internationale de la photographie, exh. cat. (Arles, 2001)

Tung, Lisa, *wonderland* (Boston: Massachusetts College of Art, 2001)

Weinberg, Adam, *anna gaskell* (Andover: Addison Gallery of American Art, 2002)

Williams, Val, *Anna Gaskell*, exh. brochure (Göteborg, Sweden: Hasselblad Center, 1999)

Windsor, Esther, ed., *The Citibank Private Bank Photography Prize 2000* (London: The Photographer's Gallery, 2000)

Wolf, Sylvia, *Visions from America: Photographs from the Whitney Museum of American Art, 1940–2001* (New York: Prestel, 2002)

Articles

Aletti, Vince, "Voice Choices: Anna Gaskell," *Village Voice*, Dec. 7, 1999, 84

———, "Male Female," *Aperture* (summer 1999), 90–91

Alton, Jeannine, "At Ease in the City and a Land of Wonder," *Oxford Times*, Apr. 23, 1999

Avgikos, Jan, "Anna Gaskell's Girl Art," *Parkett* 59 (2000), 168–72

———, "Anna Gaskell," *Artforum* (Feb. 1998), 93

Backhaus, Catrin, "Anna Gaskell in Kölnischen Kunstverein," *Kunst-Bulletin* (Sept. 2001), 48

Bayliss, Sarah, "Anna Gaskell Photographs the Underside of Girlhood," *Boston Sunday Globe*, Mar. 24, 2002, Arts and Entertainment sec., L4

———, "Innocent or Not So? The Shifting Visions of Childhood," *New York Times*, Mar. 14, 1999, 41, 45

Bishop, Claire, "Anna Gaskell," *Untitled* (summer 1999), 20

Burton, Johanna, "Art Reviews: Anna Gaskell, Resemblance," *Time Out New York*, Nov. 8–15, 2001

"Castello di Rivoli: Anna Gaskell/Form Follows Fiction," *Zoom* (Feb. 2001), 10–15

Clifford, Katie, "Reviews: Anna Gaskell," *Artnews* (Mar. 1998), 176

Cohen, Michael, "Global Art: Anna Gaskell," *Flash Art* (Jan.–Feb. 1998), 101

Cotter, Holland, "Art in Review: The Name of the Place," *New York Times*, Jan. 31, 1997, C28

Daigle, Claire, "Pagan Stories," *New Art Examiner* (Mar. 1988), 55–56

"The Dividing Lines between Real Life and Fantasy in Photography," *The Independent*, Mar. 25, 2001

Doherty, Claire, "Between Darkness and Light, Perceptions of the Paranormal," *Contemporary Visual Arts* (May 1999), 36–41

Exley, Roy, "Reviews: Anna Gaskell," *Artpress* (June 1999), 67–69

Feinstein, Roni, "Report from Miami: Part I, Museum Salsa," *Art in America* (May 1999), 65–66

Frankel, David, "Focus: The Name of the Place," *Artforum* (May 1997), 104

French, Christopher, "Anna Gaskell: The Menil Collection," *Flash Art* (Nov.–Dec. 2002), 104

Gaskell, Anna, "Top Ten: Anna Gaskell," *Artforum* (summer 2000), 54

Gisbourne, Mark, "I Love New York: Crossover of Contemporary Art," *Contemporary Visual Arts* 22 (1999), 77

"Gloomy Girl's Fantasy," *Studio Voice* (Apr. 2002), 23

Griffin, Tim, "Universal Pictures," *World Art* 18 (1998), 60–64

Gunning, Olivia, "Prints of Darkness," *The Face* (Jan. 2000), 20

Halle, Howard, "Next Wave: Four Emerging Photographers," *On Paper* (Mar.–Apr. 1998), 32–37

Hay, David, "Photographs on a Wall, Doors to a Haunted Manor," *New York Times*, Sept. 29, 2002, Arts and Leisure sec., 37

Hunt, David, *Tema Celeste* (Jan. 2002), 40–43

"Image Is Everything," *Evening Standard*, Feb. 10, 2000

Imhof, Dora, "Unheimlich/Uncanny," *Art on Paper* (July–Aug. 1999), 59–60

Jocks, Heinz-Norbert, "I Love New York," *Kunstforum* (Jan.–Feb. 1999), 320

Johnson, Ken, "Desiring Machines," *New York Times*, May 3, 2002, E39

Keats, Jonathan, "Anna Gaskell," *Art and Auction* (Mar. 2002), 56

Keith, Patrick, "Global Vision: New Art from the 90s," *Contemporary Visual Arts* 22 (1999), 70–71

Kent, Sarah, "Anna Gaskell," *Time Out London*, Feb. 24, 1999

Kief, Dieter, "Am Ende richtig Unheimlich," *Langenthaler Tagblatt*, Apr. 14, 1999, 70–71

"Kunst: Anna Gaskell," *Cosmopolitan* (German ed.) (Apr. 1999)

"Like Alice . . . ," *British Journal of Photography*, Apr. 14, 1999

McLaren, Duncan, "Pick of the Gallery: Citibank Private Bank Photography Prize 2000," *The Independent*, Feb. 2, 2000, 18

Moliterni, Rocco, "La ragazza ideale," *La Stampa*, Oct. 14, 2001

Morgan, Chris, "Sightings," *Contemporary Visual Arts* 18 (1998), 71

Muir, Robin, "Child's Play," *The Independent Magazine*, Feb. 12, 2000, 12

Mullin, Diane, "Stills: Emerging Photography in the 1990s," *Flash Art* (May–June 1998), 71

Muscionico, Daniele, "Das dunkle Geheimnis der doppelten Lottchen," *Neue Zürcher Zeitung*, Apr. 13, 1999

Oppenheim, Florence, "Alice i Underlandet," *Foto* 2 (2000)

Parola, Lisa, "Anna Gaskell, un'indagine sulla donna," *Torino Sette* (Oct. 2001)

Peacocke, Helen, "A Pioneer on the Doorstep," *Oxford Times*, Apr. 23, 1999, 2

Pietsch, Hans, "Wie Alice einen langen Hals bekam," *Art* (May 1999), 89

Pollack, Barbara, "Lights, Action, Camera!," *Artnews* (Feb. 2000), 126–31

"Rivoli," *Il Giornale dell'Arte* (Oct. 2001), 10–11

Romano, Gianni, "Anna Gaskell," *Zoom* (July 1999), 25

Saltz, Jerry, "Anna Gaskell, 'Wonder,'" *Time Out New York*, Dec. 11–18, 1997, 42

———, "Cecily Rose Brown, Bonnie Collura, Anna Gaskell," *Time Out New York*, Mar. 6–13, 1997

———, "The Name of the Place," *Time Out New York*, Feb. 6, 1997, 42

Schwendener, Martha, "Anna Gaskell, 'By Proxy,'" *Time Out New York*, Dec. 9–16, 1999

Searle, Adrian, "Life Thru a Lens," *The Guardian*, May 4, 1999, 12

Serisi, Gabriella, "Anna Gaskell," *Segno* (Jan.–Feb. 2002)

Shave, Stuart, ed., "Scenes from the Edge," *i-D* (Mar. 1999), 144

Smith, Roberta, "At the Guggenheim, Selected Short Subjects," *New York Times*, July 19, 2002, E35

———, "Painting and Photos with Tales To Tell, Often about the Oddities of Growing Up," *New York Times*, Dec. 5, 1997, B27

———, "The World through Women's Lenses," *New York Times*, Dec. 13, 1996, C28

Squires, Carol, "Anna in Wonderland," *American Photo* (Jan.–Feb. 1999), 34

Tuchman, Phyllis, "Variety Photoplays," *Art in America* (June 2002), 106–15

———, "Connoisseur's World: Photography: A T&C Guide," *Town and Country* (Dec. 2001), 53–60

Turner, Elisa, "Girl Power Takes the Stage," *Miami Herald*, Oct. 25, 1998, 2

Wakefield, Neville, "Three To Watch," *Elle Decor* (Aug.–Sept. 1999), 82–86

Yablonsky, Linda, "Casey Kaplan Shows Anna Gaskell," *Art and Auction*, Nov. 15, 1999, 84